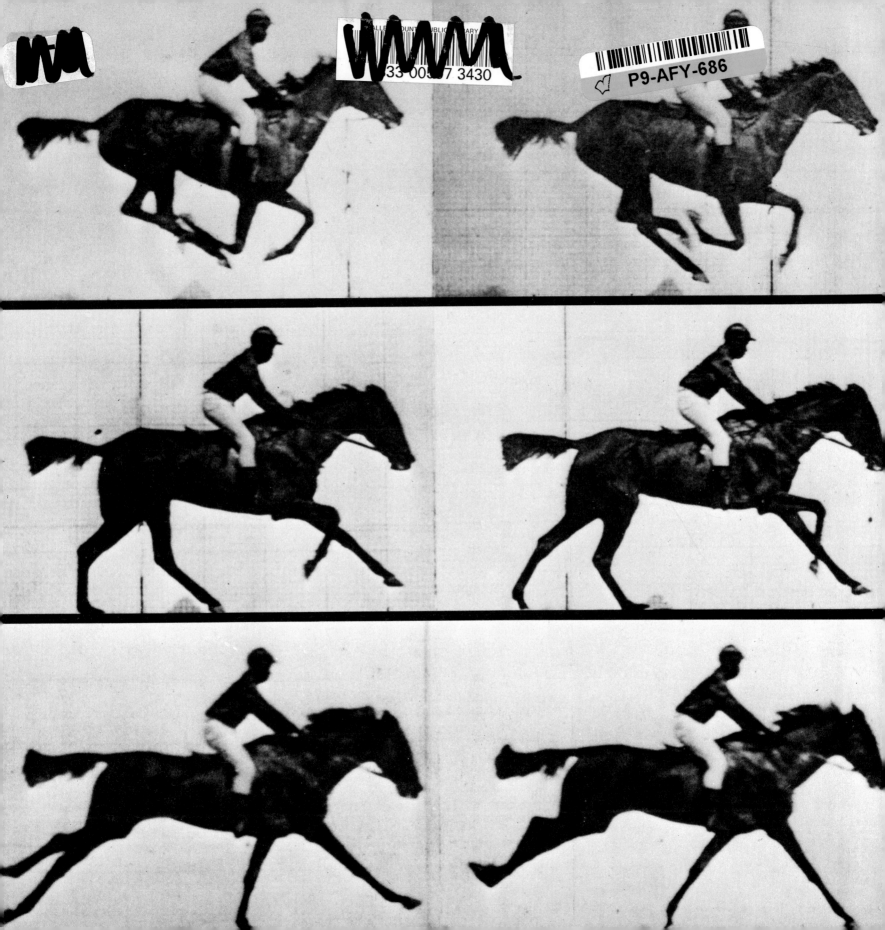

Endpapers: *Racehorse Annie in Motion,*
by Eadweard Muybridge,
about 1885, Library of Congress

Title page: *Buzz Aldrin on the Moon,*
by Neil Armstrong, 1969, National
Aeronautics and Space Administration

THE ART OF PHOTOGRAPHY

BY SHIRLEY GLUBOK

Designed by Gerard Nook

MACMILLAN PUBLISHING CO., INC.
New York
COLLIER MACMILLAN PUBLISHERS
London

For Alfred Tamarin,
my husband and special photographer

The author gratefully acknowledges the assistance of:
Ben Attas, Technical Consultant, Modernage Custom Darkrooms; *Susan Kismaric*, Research Supervisor, Department of Photography, The Museum of Modern Art; Library Staff of The Museum of Modern Art; *Grace M. Mayer*, Curator of the Steichen Archive, The Museum of Modern Art; *David J. Wanger; Hilary Caws;* and especially the helpful cooperation of *Weston J. Naef*, Associate Curator, Department of Prints and Photographs, The Metropolitan Museum of Art; and *John Szarkowski*, Director, Department of Photography, The Museum of Modern Art.

Macmillan Publishing Co., Inc., 866 Third Avenue, New York, N.Y. 10022
Collier Macmillan Canada, Ltd.
Printed in the United States of America

10 9 8 7 6 5 4 3 2 1

LIBRARY OF CONGRESS CATALOGING IN PUBLICATION DATA
Glubok, Shirley. The art of photography. SUMMARY: A survey of photography as a fine art from the 1830's to the present, focusing on outstanding photographers and their work.
1. Photography, Artistic—Juvenile literature. [1. Photography, Artistic] I. Title. TR642.G59
770 77–4985 ISBN 0–02–736680–4

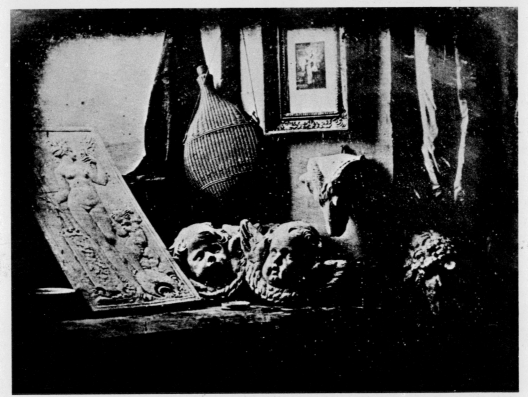

The Artist's Studio, 1837, Société Française de Photographie, Paris, courtesy of The Metropolitan Museum of Art

Photography, or "writing with light" in order to make a permanent image, has only been known for about one hundred and fifty years. For centuries artists and scientists had been aware that light can create fleeting images on a surface. But no one had succeeded in fixing an image to make it last.

In 1837 Louis Jacques Mandé Daguerre, a French artist, found a way to make an image permanent by using a sheet of silver-plated copper treated with a chemical to make it sensitive to light. The silver is changed by the effects of light and an image becomes visible on the metal after it has been treated in a box with fumes of heated mercury. A picture produced by Daguerre's process, called a "daguerreotype," is a direct, mirrorlike image on a polished silver surface. Each daguerreotype is unique; there is no negative. The daguerreotype above was taken by Daguerre in his studio.

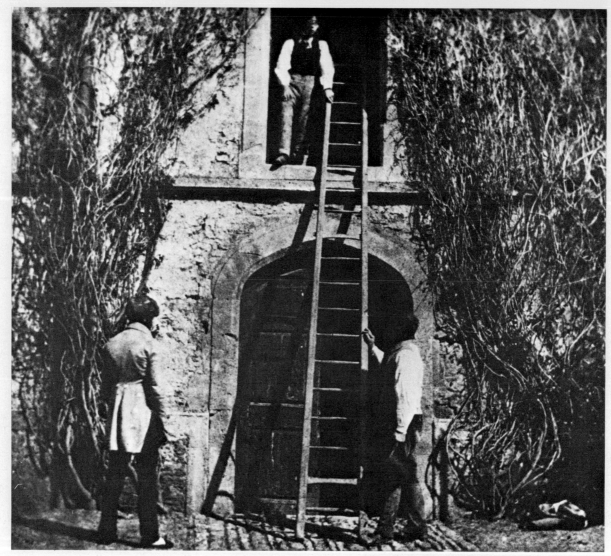

The Ladder, 1844, International Museum of Photography
at George Eastman House, Rochester, New York

William Henry Fox Talbot invented the process of producing a negative from which many positive pictures could be printed. Talbot's negatives were papers which had been chemically treated to make them light-sensitive. Positive prints were made by projecting light through the negative onto photographic paper. A photograph produced by Talbot's paper negative process is called a "calotype," which means "beautiful picture."

Three men posed at the photographer's home in England for the calotype above.

It appeared in a book Talbot wrote, which was the first book ever to be illustrated with photographs. Prints of Talbot's pictures had to be individually pasted onto the pages because a way of reproducing photographs on a printing press was not yet known.

In France, Charles Nègre, a painter, began taking photographs as studies for his paintings. Nègre's photographs of daily life in Paris soon proved to be works of art in themselves. He used a paper negative process for the photograph at right. Two small children are listening to the music of a street organ, while the old man seems lost in his own thoughts. Nègre was one of the first camera artists to see beauty in everyday scenes.

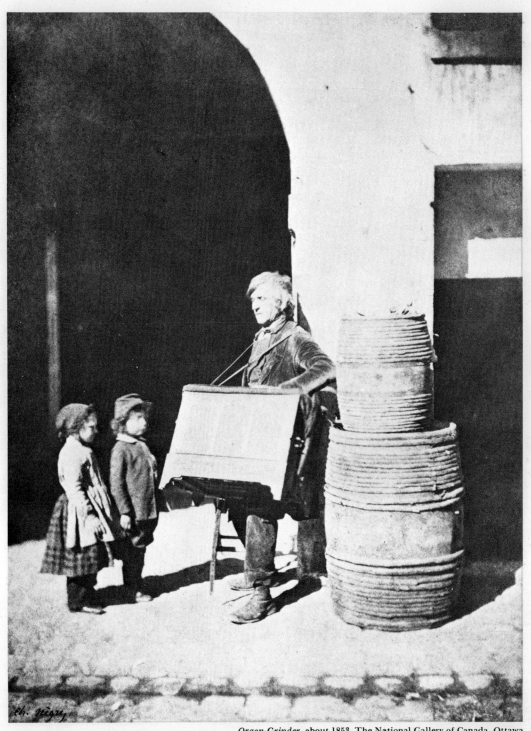

Organ-Grinder, about 1853, The National Gallery of Canada, Ottawa

5

The earliest team of artist-photographers were David Octavius Hill and Robert Adamson. They took the picture below in the fishing village of Newhaven, Scotland. The details in it are soft because it was made from a paper negative. The overhead sun highlights the figures of the fisherman and the boys and creates deep shadows. The boat makes an interesting form and at the same time helps the subjects to hold their poses without moving during the long exposure. To take this picture, the camera lens had to be open for more than a minute. A tripod, or three-legged stand, was used to hold the camera steady.

About the time Hill and Adamson were making calotypes in Scotland, Albert Sands Southworth and Josiah Johnson Hawes were operating a daguerreotype studio in Boston. Many notable Americans, including President John Quincy Adams and Senator Daniel Webster, were photographed by them. They took the picture at right, of students in a girls' school in Boston, using only the daylight coming through the window. Artificial light for photography had not yet been invented. The subjects in the picture seem relaxed, even though they had to hold themselves motionless for half a minute.

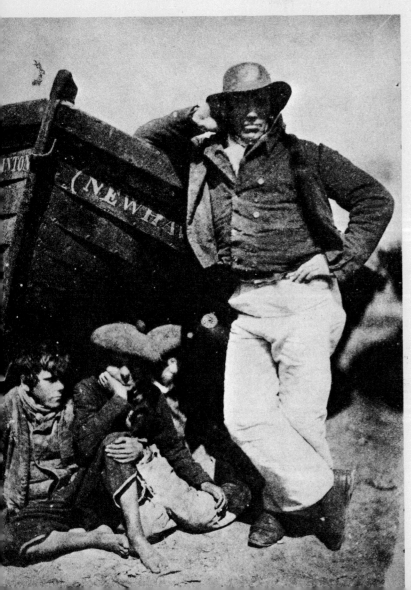

A Newhaven Fisherman and Three Boys,
1845, The Metropolitan Museum of Art,
Harris Brisbane Dick Fund

Emerson School, about 1855,
The Metropolitan Museum of Art,
Gift of I. N. Phelps Stokes and the Hawes Family

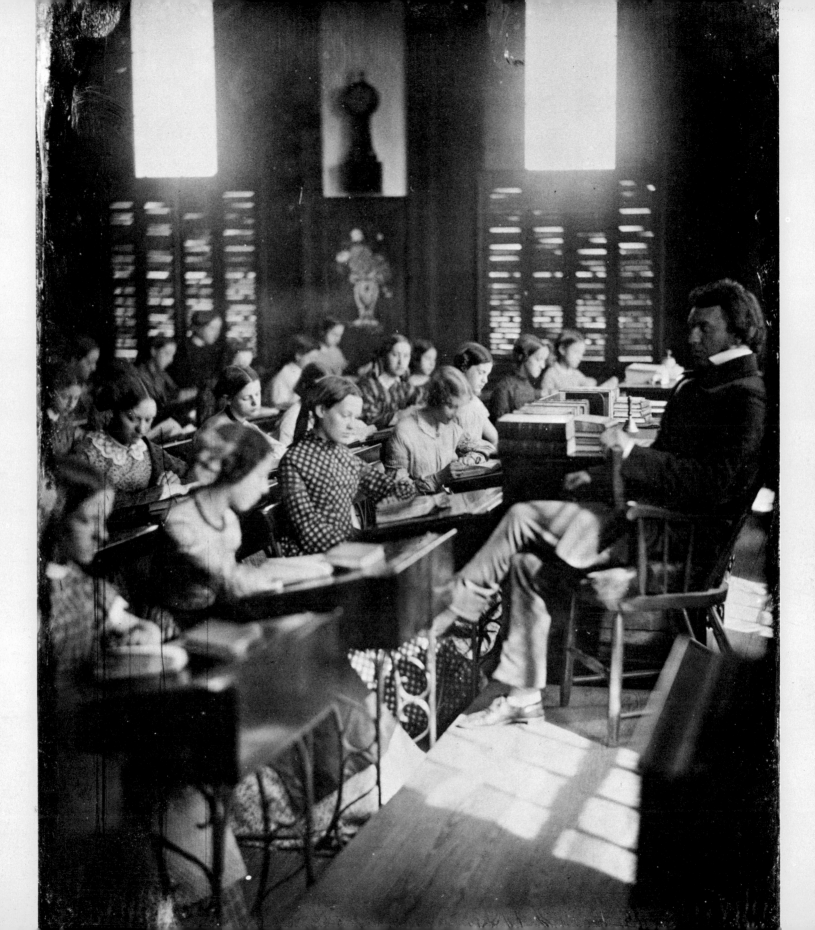

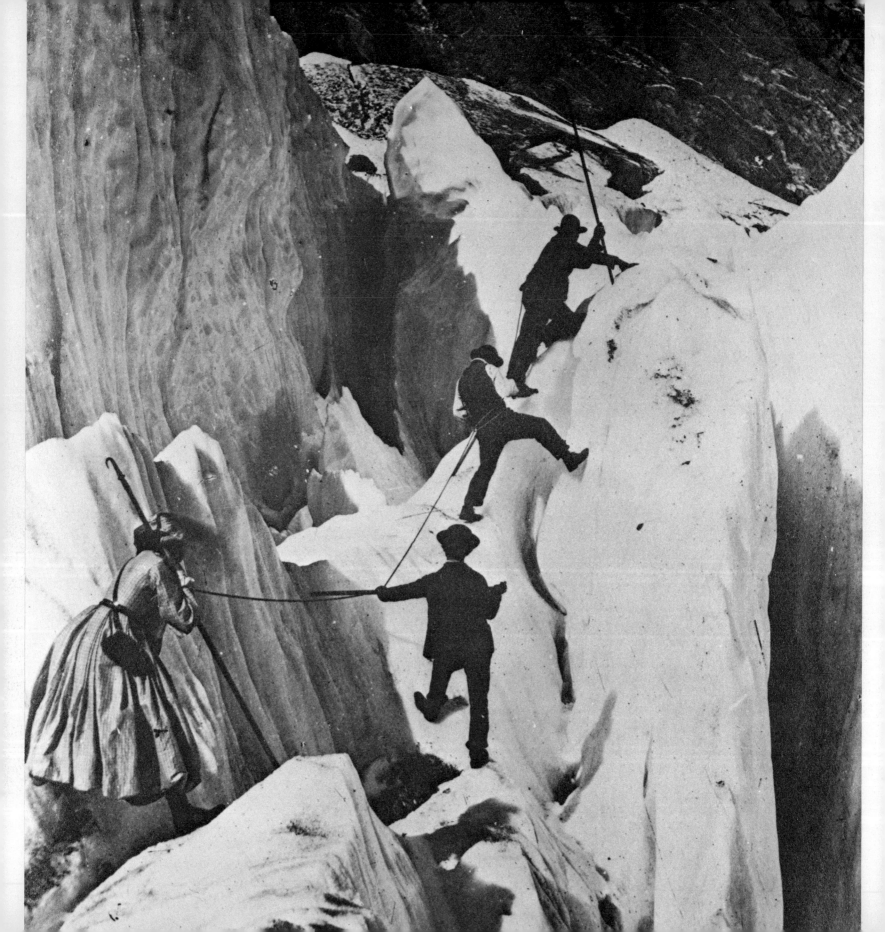

ethods of making light-sensitive silver salts adhere to glass were developed about 1850, and the glass negative came into use. Cameramen started traveling to all parts of the world to record unusual scenes. Adolphe Braun, a Frenchman, went to the Alps to take the picture at left of people climbing on a glacier. The woman in her cotton dress and men in their black suits and hats look strangely out of place against the icy mountainside. The photograph captures the texture of the sparkling snow.

Braun had been a designer of flower patterns for printed cloth. He began to photograph flowers as studies for his designs. Later he turned to photographing street views of Paris and fashionable French people.

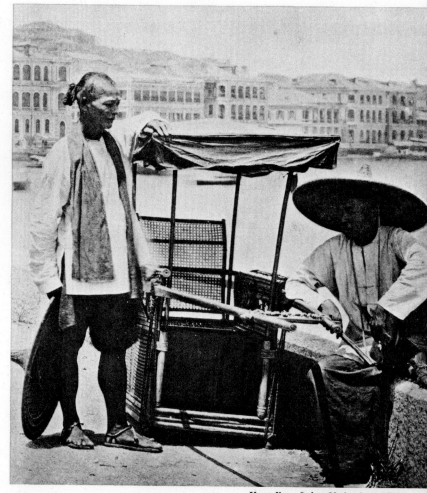

The photograph at right was taken by the Englishman John Thomson in Hong Kong. Two men pose by a sedan chair in which they carry passengers along the streets of the city. As a result of his travels, Thomson wrote a four-volume work on China, illustrated with his own photographs. It was one of the first books to contain photographic illustrations that were printed on a press. Thomson also used his camera to make a record of street life in London.

Hong Kong Sedan Chair, about 1870,
The Metropolitan Museum of Art,
Elisha Whittelsey Fund

Climbing in the Alps, about 1860,
The Metropolitan Museum of Art,
David H. McAlpin Fund

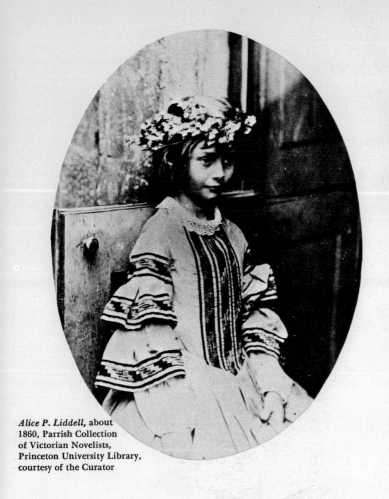

Alice P. Liddell, about
1860, Parrish Collection
of Victorian Novelists,
Princeton University Library,
courtesy of the Curator

Photography grew in popularity in England during the Victorian period. This period was named after Queen Victoria, who ruled from 1837 to 1901. Charles Dodgson, who wrote children's books under the pen name of Lewis Carroll, often photographed little girls dressed up in costumes and acting out stories. At left is his portrait of eight-year-old Alice Liddell, for whom he wrote *Alice's Adventures in Wonderland.*

Julia Margaret Cameron photographed famous people who came to her home to visit. Among them were the poets Alfred, Lord Tennyson and Henry Wadsworth Longfellow, and the scientists Charles Darwin and Sir John Herschel.

Cameron's close-up of Herschel shows him as a man of great energy and intelligence. Herschel was an astronomer, and he also played an important part in the chemistry of photography. He created the chemical bath called "hypo" used in the developing and printing process. This bath dissolves the silver salts on the film, stops the development and fixes the image. Herschel also introduced the terms "photography," "negative," "positive" and "snapshot," which came to be used internationally.

Sir John Herschel, 1867,
The Metropolitan Museum of Art,
David H. McAlpin Fund

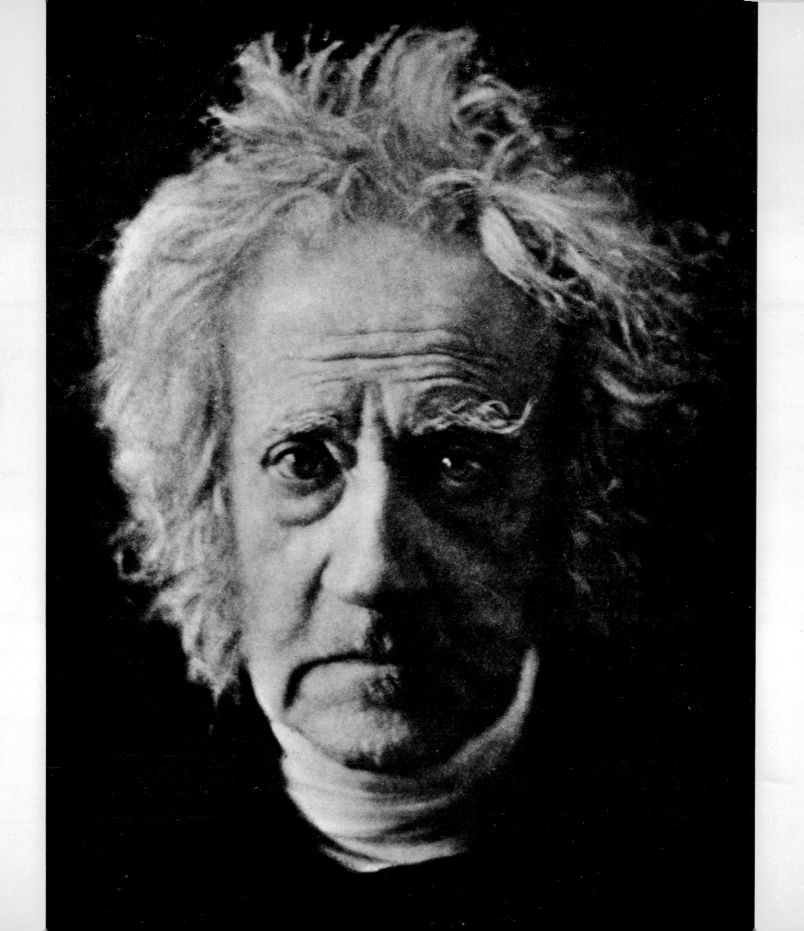

11

Roger Fenton, another Englishman, was one of the first photographers to take pictures of an army at war. With a horse-drawn wagon as a photographic darkroom, he joined the troops in the Crimean war. He did not take pictures of the actual battles because photography had not yet reached the point where the camera could stop rapid motion.

Fenton, like all nineteenth-century photographers, traveled with a vast amount of equipment: five cameras and several lenses, chests of chemicals, printing frames and apparatus for purifying water. He also took along about seven hundred glass plates. Fenton used the wet-plate process for his negatives. In his darkroom wagon he would coat a plate of glass with a very sticky solution called collodion, which made light-sensitive silver salts stick to the glass. The sensitized plate had to be hurried to the camera while wet

Cantinière Tending Wounded Man, 1855, Gernsheim Collection, Humanities Research Center, University of Texas, Austin

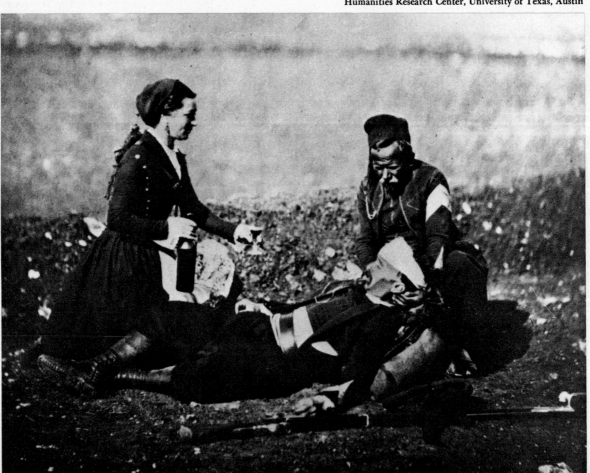

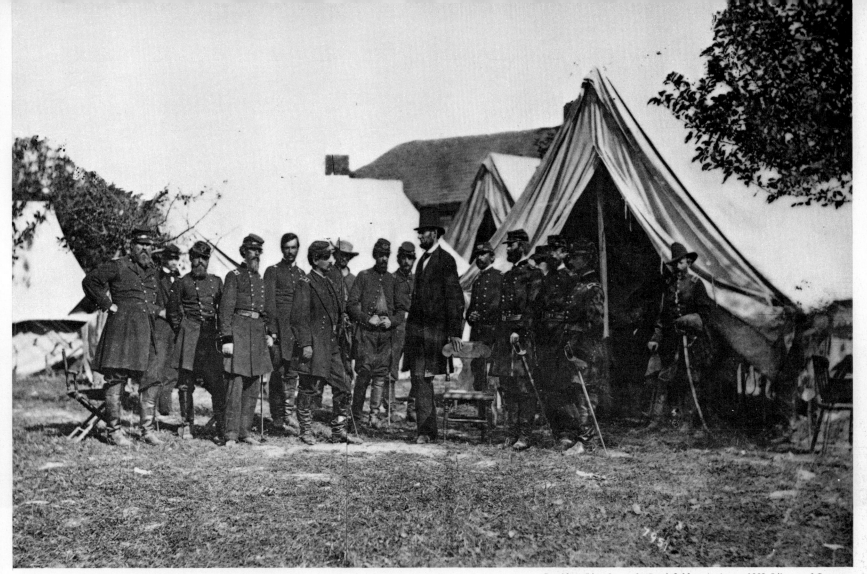

President Lincoln on the Battlefield at Antietam, 1862, Library of Congress

and the picture taken before the solution dried. The plate was then rushed back to the darkroom wagon and developed immediately.

In the United States, when war broke out between the North and South in 1861, photographers went with the soldiers onto the battlefield. Alexander Gardner recorded President Abraham Lincoln's meeting with General George McClellan after the Northern armies had driven back General Robert E. Lee's advancing Confederate forces in the Battle of Antietam. Southerners refer to it as the Battle of Sharpsburg.

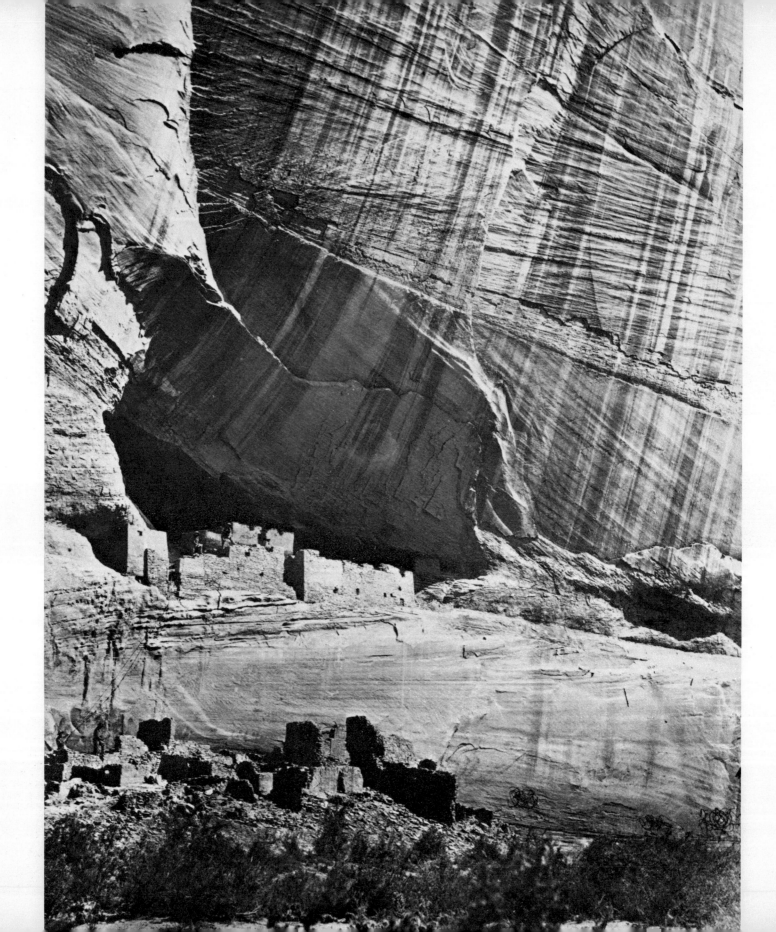

14

As the United States expanded westward, the government sent expeditions that included photographers to study the mountains and rivers, the animal and plant life, and the Indians who occupied the land. Timothy O'Sullivan, who had worked on the Civil War battlefields, went with expeditions to explore the Isthmus of Panama, the Colorado River and the Grand Canyon.

While in Nevada, O'Sullivan descended into the blackness of a gold mine called the Comstock Lode, where the only light came from the flickering lamps on the miners' hats. Using newly invented magnesium powder which exploded into a flash of light when ignited by a spark, O'Sullivan took some of the earliest mining photographs.

In the bright sunlight of Arizona, he photographed the sheer wall of the Canyon de Chelly. Tucked beneath a rocky overhang are the ruins of ancient Indian dwellings.

Edward S. Curtis worked as photographer for a scientific expedition that explored the Northwest coast. Later he studied Indian tribes west of the Mississippi from Alaska to New Mexico, recording their history, customs and beliefs. In the Columbia River basin, he photographed a Nez Percé on horseback.

A War Chief—Nez Percé, 1905, Library of Congress

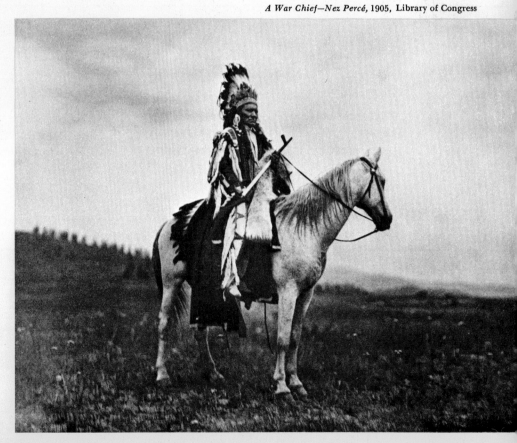

Ancient Ruins in the Canyon de Chelly,
1873, Library of Congress

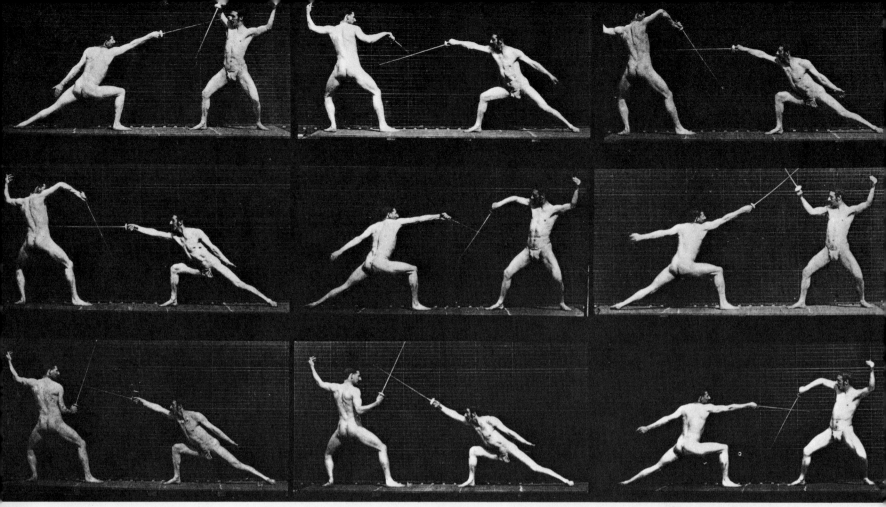

Athletes Fencing, about 1885, Library of Congress

adweard Muybridge, who was always experimenting with cameras and film, was

the first to record a horse at full gallop. A horse runs so fast that the human eye

cannot see the exact positions of its legs. Muybridge set up a series of cameras along a

race track and stretched threads across the track, attaching them to the shutters of

the cameras. Whenever a running horse broke a thread, a shutter opened and closed and

a picture was taken. Muybridge's photographs enabled artists, for the first time, to

make accurate paintings of a running horse.

Muybridge also mounted groups of cameras to photograph the movements of athletes

at intervals of a fraction of a second. Individual pictures of fencers were put together

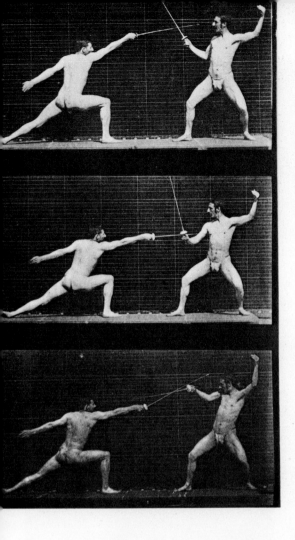

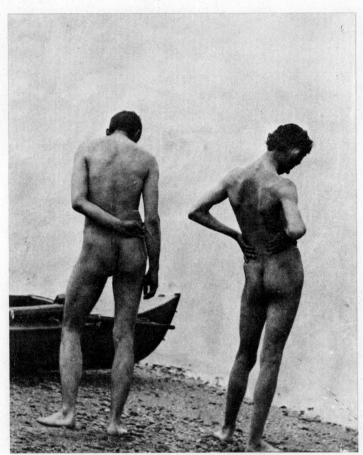

Two Men on Beach, about 1880, The Metropolitan Museum of Art,
David H. McAlpin Fund

to make the sequence above. When projected onto a screen in quick succession, the series of movements seems to create continuous motion. Muybridge's experiments led to the development of modern motion pictures.

One of America's greatest painters, Thomas Eakins, was keenly interested in Muybridge's experiments. Eakins himself made motion studies of athletes, using a method of multiple exposures on a single negative. He was so eager to show the human body correctly in his paintings that he studied anatomy at a medical college. Eakins's photographs of the nude male body in different positions were useful guides for his paintings, and are works of art in themselves.

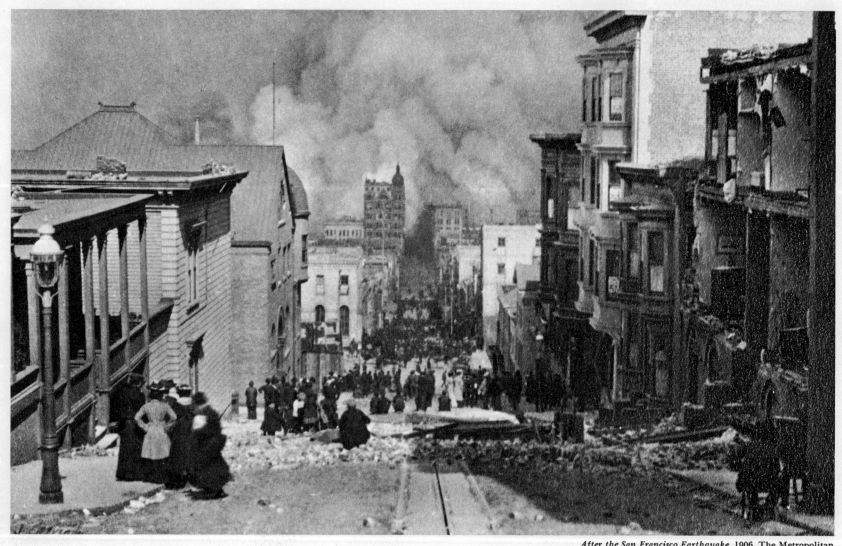

After the San Francisco Earthquake, 1906, The Metropolitan
Museum of Art, Alfred Stieglitz Collection

Arnold Genthe had a studio in San Francisco where he made portraits of fashionable

people. In 1906 when the city was hit by an earthquake, his studio was destroyed and

all of his cameras and glass plates were smashed. With a borrowed camera he went out on

the streets to photograph the wreckage. As he walked through the rubble of the city,

he recorded earthquake victims staring at the fires that broke out.

The camera borrowed by Genthe was a Kodak Brownie. The Kodak, invented by

George Eastman in 1888, uses a roll of factory-made film. Wet-process plates had to be developed immediately, but roll film, which is coated with dry chemicals, can be developed later. The Kodak is small and lightweight, so it can be held in the hand.

Lewis Hine used the camera to make revealing pictures of the hardships of city life in New York, in the hope that these would help bring about social change. He took pictures in dark mines and in dingy factories where young children labored from morning until night. His pictures helped to encourage the passage of new child labor laws and the enforcement of old laws.

At Ellis Island in New York Harbor, Hine came upon an immigrant Italian family looking for their baggage. His picture at right catches the hope and fear on the faces of the mother and her children.

In later years Hine photographed men at work. He was the official photographer for the Empire State Building when it was erected in 1931. Hine climbed upward with the steelworkers, floor by floor, until he reached the girders on top of what was then the tallest skyscraper in the world.

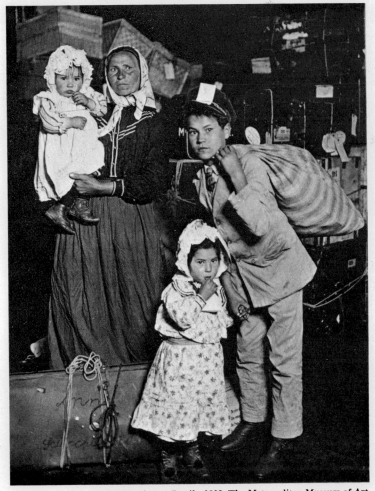

Italian Immigrant Family, 1908, The Metropolitan Museum of Art, Gift of Mr. and Mrs. Wolfgang Pulverman

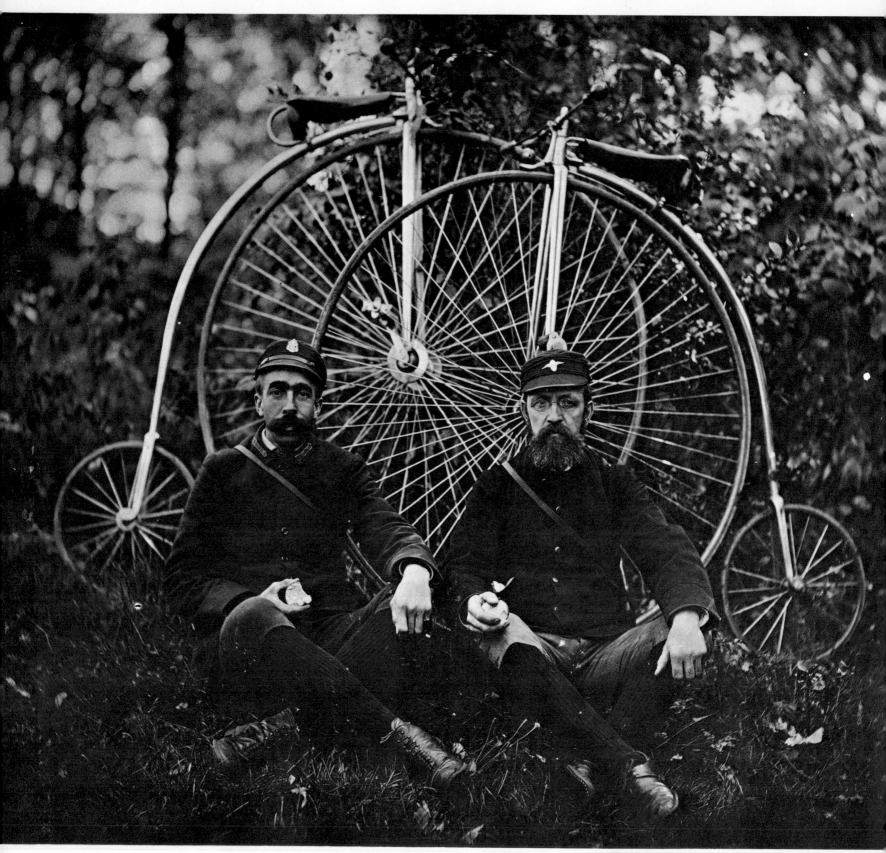

The Bicycle Messengers Seated, about 1900, Library of Congress

Life in New England at the turn of the twentieth century was recorded by Charles H. Currier, who took views of buildings and business establishments in Boston. When he posed these messengers in uniform, he created a balanced pattern of shapes: the seated men with their legs crossed, behind them the round wheels and the radiating spokes of the old-fashioned bicycles. The half-eaten apples that the men are holding make it seem as if they were interrupted in the middle of their lunch.

Wandering the streets of Paris, Eugène Atget photographed the life of the city, the people, shops, carriages and buildings. He took pictures of the palaces of the rich, the simple homes of the poor, of ragpickers and elegant ladies in fashionable clothes. He asked strangers and passersby to pose for him. This peddler of lampshades stopped for a moment on the cobblestone street. In addition to being a beautiful portrait, the photograph is an interesting arrangement of triangles, circles and rectangles.

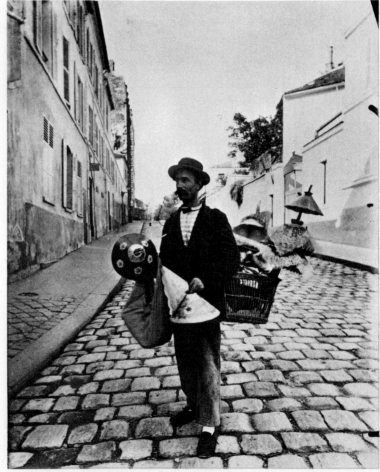

Lampshade Peddler, about 1910, International Museum of Photography at George Eastman House, courtesy of Berenice Abbott

Spring, 1901, Helios Gallery, New York

Alfred Stieglitz believed that great photographs can be taken anywhere; the quality of the photograph depends on the eye of the photographer. Cloud formations in sunlight and moonlight, shimmering leaves, blades of grass and his daughter, Katherine, were favorite subjects.

On a voyage from New York to Europe, Stieglitz was strolling along the upper deck of the ship. As he looked down, he saw a mass of people crowded in the steerage, or lower decks. He rushed back to his cabin to get his camera and took the picture at right. Stieglitz was fascinated by the patterns formed by the walkway with its curved chains, the tall round smokestack and the iron stairway, and the shawls and hats of the people.

Stieglitz proclaimed that photography is a fine art, equal to painting and sculpture. He formed a group known as Photo-Secession and opened a gallery at 291 Fifth Avenue in New York City to exhibit the members' photographs. He also edited a magazine called *Camera Work* that published pictures by the leading photographers of the day. The "291" gallery showed modern painting and sculpture along with photography. Pablo Picasso, Henri Matisse and Vincent Van Gogh, whose art was popular in Europe at the time, were introduced to America at "291." Exhibitions of work by modern American artists such as Arthur Dove and John Marin were held there as well.

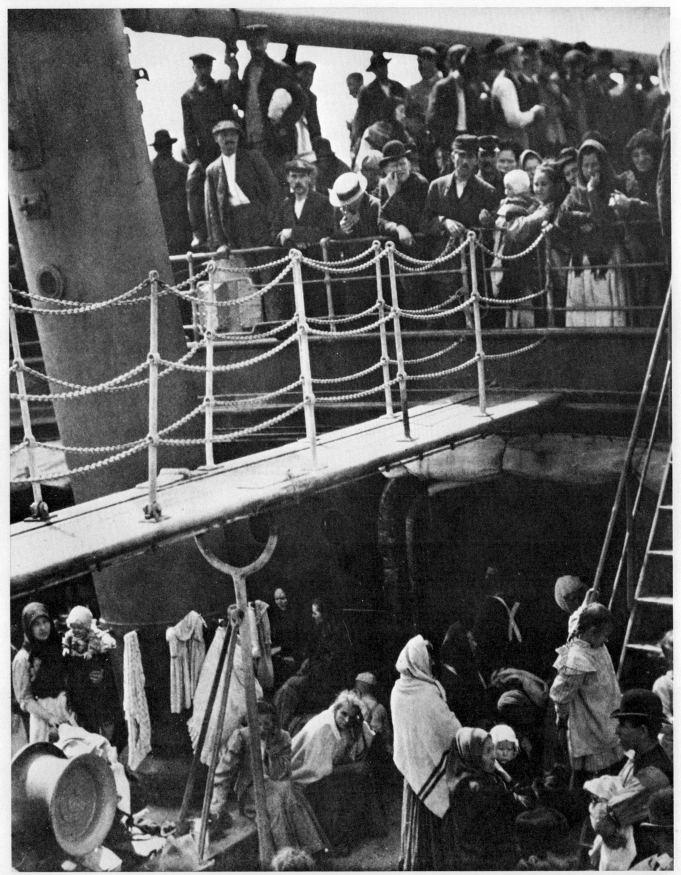

The Steerage, 1907, Helios Gallery

23

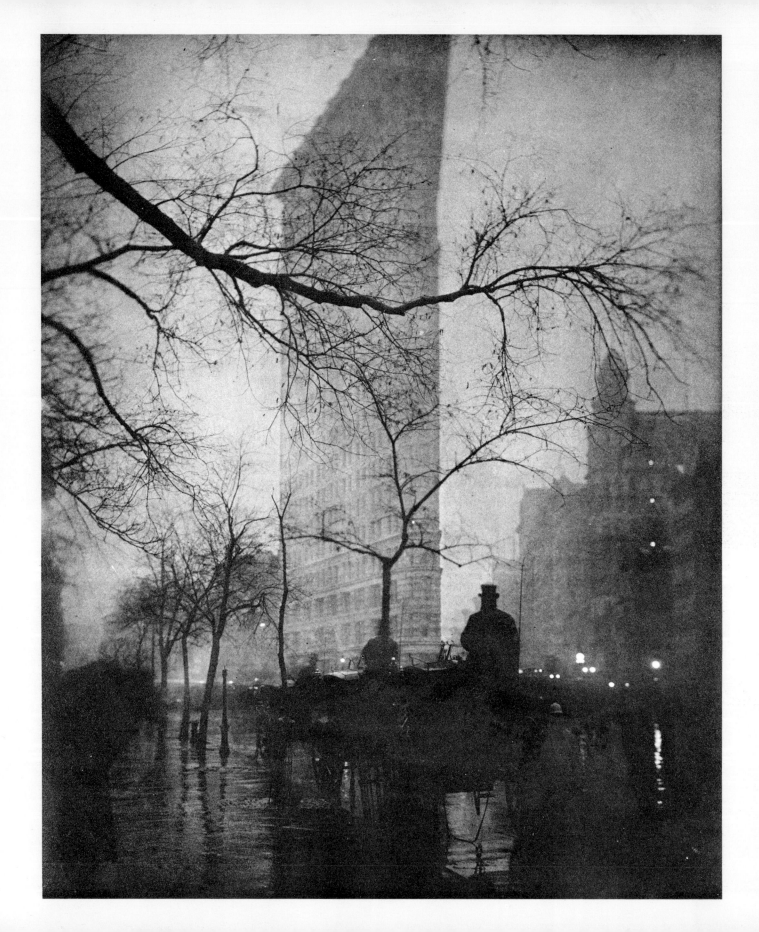

24

Edward Steichen was one of the young photographers whose work Stieglitz published in *Camera Work* and exhibited at "291." In his youth Steichen was both a painter and photographer, but he decided to give up painting and devote himself to the camera.

This view of the Flatiron Building, taken on a rainy evening in New York City, has the quality of a painting. The mass of the structure emerges from the mist. The dark figures of the carriage drivers and the bare branches of a tree in the foreground make the building seem farther away. The Flatiron Building, which had recently been completed, was considered a masterpiece of engineering; it was constructed on a triangular piece of land.

During World War I Steichen served in the Army Air Service where he commanded the Photographic Division. Aerial photography, which was used to gather information about enemy positions, required the utmost sharpness in detail.

To study all of the possible effects of changing light and shadows, Steichen photographed a simple cup and saucer more than a thousand times. In later life, a tree near his home became one of his favorite subjects. He photographed the tree in sunshine and in rain and snow, in full leaf and bare, at all hours of the day.

Steichen brought high standards of art to commercial photography in advertisements and women's fashion magazines. "The Family of Man," the most popular photography show ever held, was organized by Steichen for The Museum of Modern Art in New York City. It was shown all over the world.

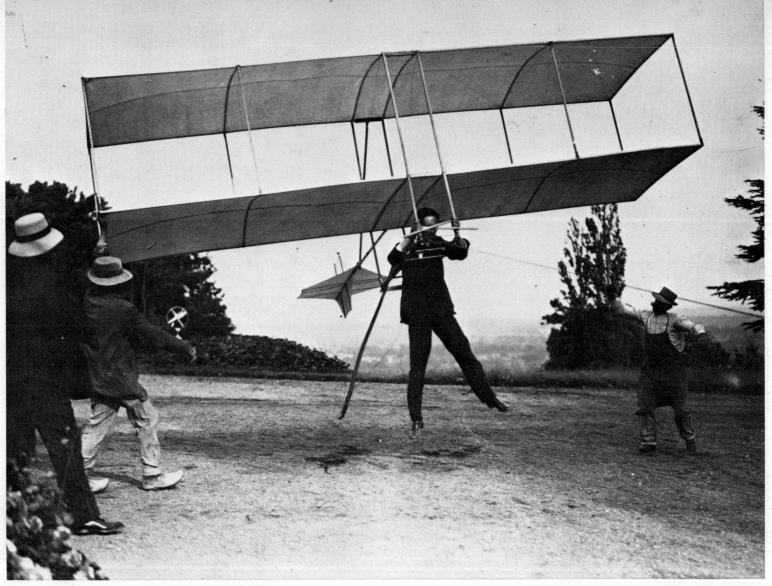

The Lartigue Family Invents a Glider, 1908, courtesy of
Jacques-Henri Lartigue

When Jacques-Henri Lartigue was six years old, his father gave him his first camera.
Since he was too young to join in the games of his older brother, cousins and their friends,
he would run after them with his camera. For the next fifteen years the boy photographer
took pictures of his family and friends racing homemade carts and boats, flying kites
and experimenting with balloons and gliders. When his older brother tried out a new
flying machine, the younger Lartigue, who was then only twelve, captured the exciting
moment when the glider was lifted into the air.

Lartigue took pictures of some of the first auto races when the automobile was still a new invention. He also photographed fashionable people strolling with their dogs on the Paris boulevards or walking on the beach under their parasols. By the time he was twenty-one, Lartigue had set his photography aside and ever since then he has devoted himself to painting.

André Kertész, who was born in Hungary, was one of the early "candid photographers." He used a small box camera to keep a private diary of events that took place around him. Kertész wandered around the city quietly taking pictures of people who were unaware of his camera. At right, a young couple in Budapest are looking through openings in a wooden fence for a peek at a circus performance. The picture makes the viewer feel that something wonderful is taking place on the other side of the fence. Kertész lives in New York where he is still active with his camera.

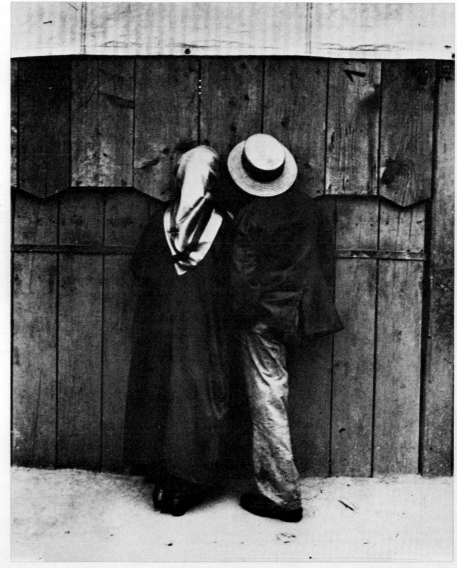

Circus, 1920, © André Kertész

Man Ray, an American painter and photographer who lived in Paris, became interested in the idea of making pictures without a camera. In a darkroom he would arrange objects on light-sensitive paper and then turn on a photographic light. When the paper was developed, areas that had been covered by the objects stayed white; the rest of the paper turned black. He called his cameraless photographs "Rayographs."

Dr. Harold E. Edgerton developed a stroboscopic lamp which can be synchronized with a camera to take pictures at a speed faster than a hundred-thousandth of a second. The flash is electronically controlled so it goes off when the shutter is open. Edgerton's photographs stop action which is much too fast for the human eye to see. At right is his high-speed photograph of the splash produced by a drop of milk falling onto a plate covered with a thin layer of milk. The droplets form a circle that looks like a crown of pearls. Edgerton has also recorded with flashing strobe lights a golfer hitting a ball, a wire struck by a bullet and the wing action of a hummingbird.

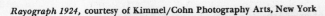

Rayograph 1924, courtesy of Kimmel/Cohn Photography Arts, New York

Milk Drop, 1936, courtesy of
Dr. Harold E. Edgerton

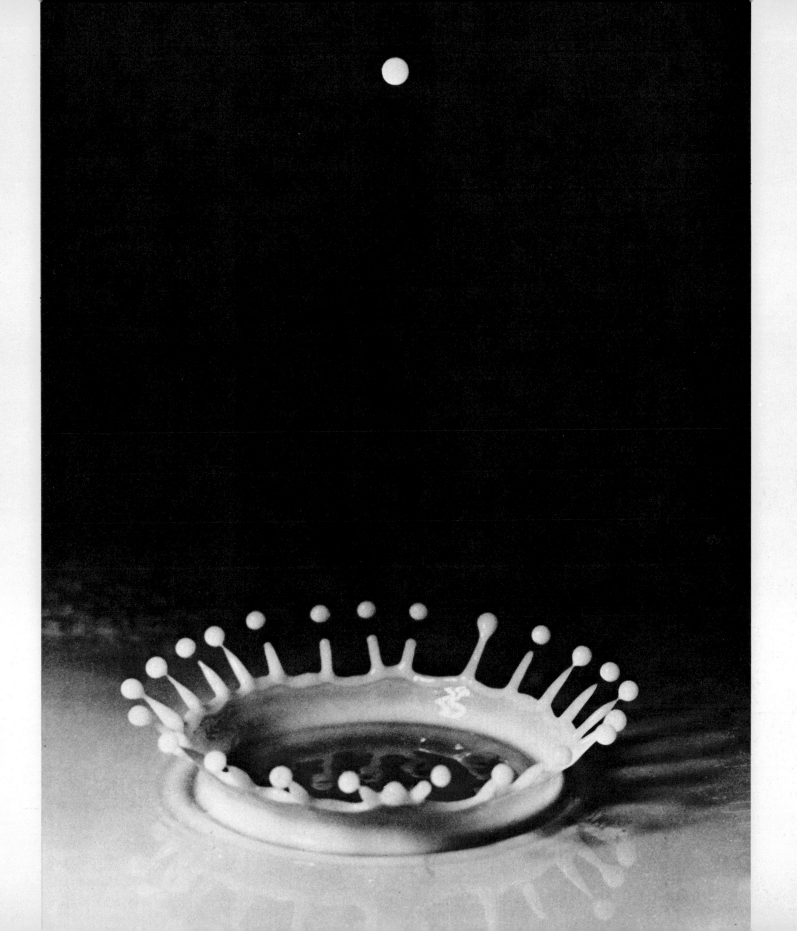

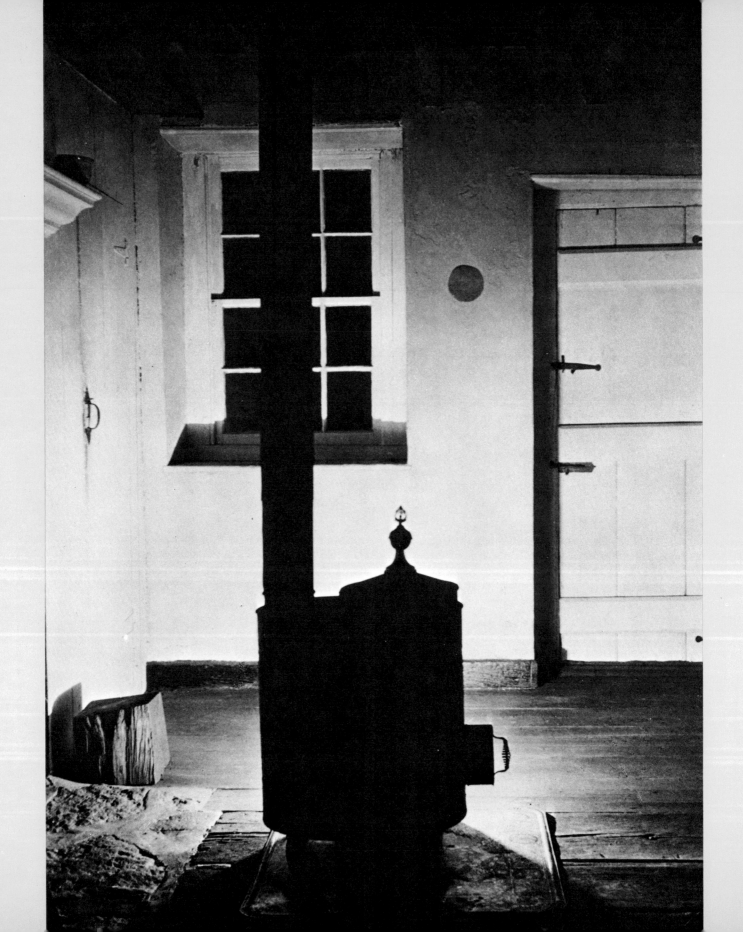

Charles Sheeler found interesting shapes in the simple room in a Pennsylvania farmhouse at left: the round wood-burning stove in the center, the block of wood on the floor and the rectangular window and door on the rear wall. The contrast of the black stove and the white wall makes the picture dramatic. Years later Sheeler made a drawing of this scene that looks almost the same as the photograph. Sheeler was an important painter as well as photographer in the early twentieth century.

Edward Weston used a large camera to take powerful close-up views of such objects as sea shells, rocks, seaweed, birds' wings, tree stumps and cabbages. Large negatives, which can only be taken in a large camera, permit more delicate variations of the black and white tones in a photograph.

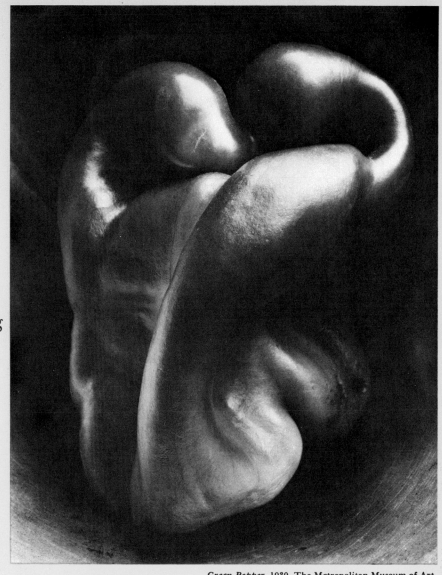

Green Pepper, 1930, The Metropolitan Museum of Art, David H. McAlpin Fund

Weston photographed a green pepper for several days to get the picture above. When he finished photographing the pepper, he cut it up and put it into a salad. Weston was one of a California group of photographers who met together in a gallery in an old studio where they exhibited their prints.

Interior With Stove, 1917,
The Metropolitan Museum of Art,
Gift of Alfred Stieglitz

31

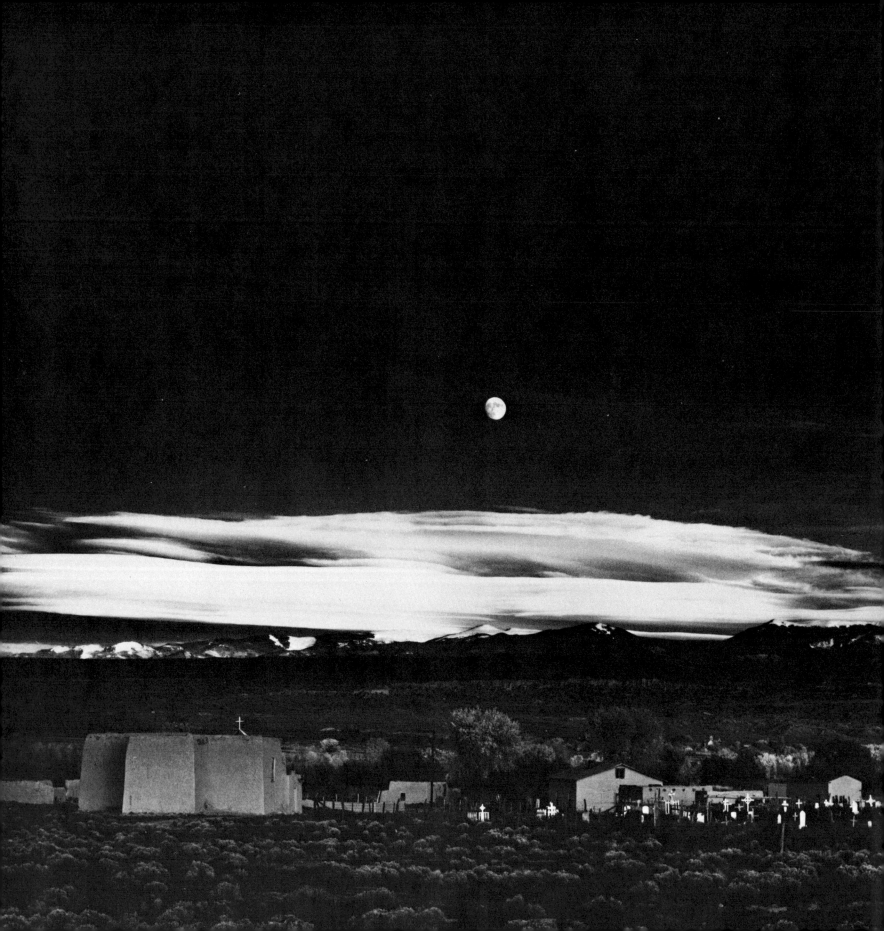

Ansel Adams, one of the Pacific Coast group, divided the intensity of light reflected from the object to be photographed into ten zones. The ten zones are stages of brightness, ranging from absolute black to dead white. A photographer who uses Adams's zone system, or gray scale, must see the final print of his picture in his mind before he releases the shutter. The system requires also that the photographer determine, before he takes the picture, the length of time of the chemical development he will give to the negative. Adams is the author of several books on photography, including the basic manual of his gray scale.

Adams is active in efforts to conserve wilderness areas in the West. He has created magnificent pictures of mountains and valleys. He photographs a blade of grass with the same care as a vast landscape. In his wide view of a New Mexican village in the moonlight, the silver moon is rising in the night sky. Dark mountains loom in the background. All the tones of gray, from black to white, are included. Photography by moonlight presents special difficulties because so little light is reflected by the moon.

Moonrise, Hernandez, New Mexico, 1941,
International Museum of Photography at
George Eastman House, courtesy of Ansel Adams

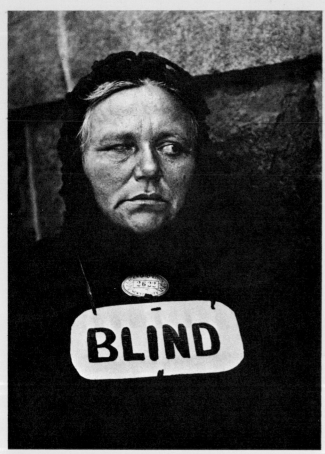

Blind, 1916, The Metropolitan Museum of Art,
Alfred Stieglitz Collection

Paul Strand captured the hidden inner strength that
is often found in the most humble human beings.
The face of the blind newspaper dealer reveals strain,
but she has a quiet dignity. Even without the sign she
is wearing on her chest, there is no doubt that her eyes are
sightless. Strand also used a camera that takes a large
negative, eight by ten inches in size.

As a boy Strand studied with Lewis Hine and
later he was closely associated with Alfred Stieglitz, who
exhibited his work in New York and published his
pictures in *Camera Work.*

In Germany August Sander recorded the faces of
hundreds of his countrymen. He photographed ordinary
people who would otherwise have passed by unnoticed.
The worker balancing a load of bricks on his shoulders
looks straight at us with a serious gaze.

Bricklayer's Mate, 1929,
The Museum of Modern Art, New York,
Gift of the Photographer, courtesy of
Sander Gallery, Washington, D.C.

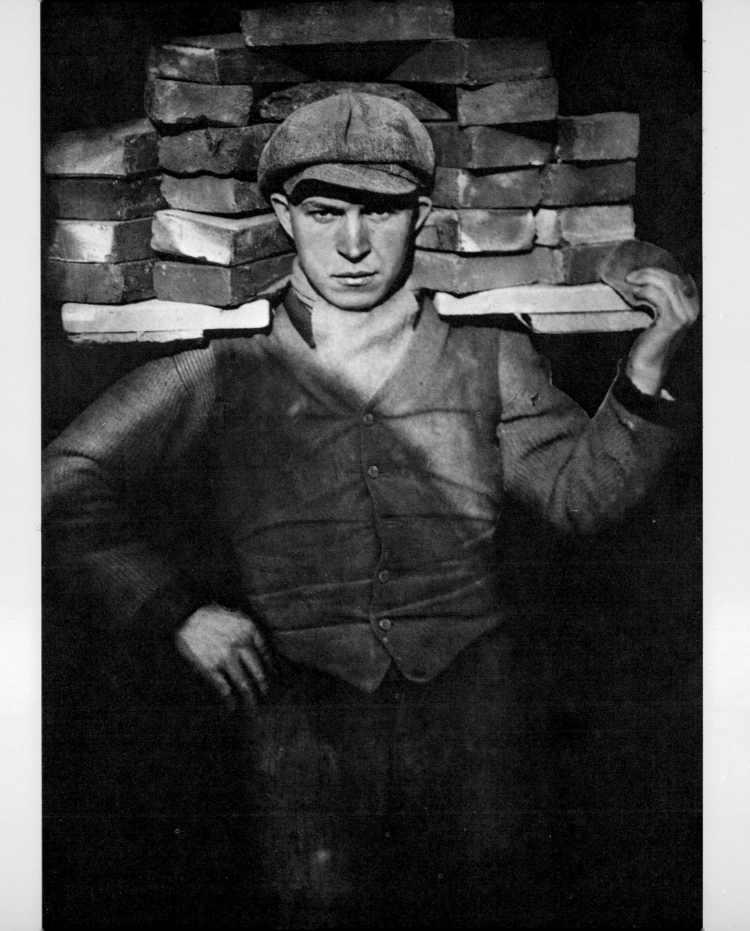

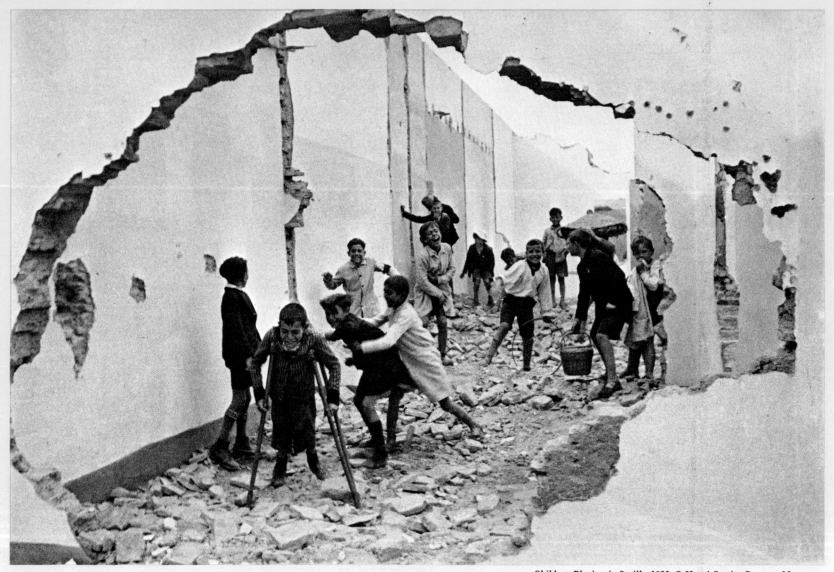

Children Playing in Seville, 1933, © Henri Cartier-Bresson, Magnum

The Frenchman Henri Cartier-Bresson uses a 35-millimeter camera, which gets its

name from the width of the negative it takes. He waits until a scene is composed; then at

the split second when the subject looks perfect to him, he releases the shutter. He

calls that point in time "the decisive moment."

 Cartier-Bresson photographed these children playing in the rubble of a city street in

Spain in the early 1930's. The picture was taken through a large hole in the wall; the hole's jagged edges frame the scene.

The endlessly changing nature of the world provides subject matter for Barbara Morgan's camera. The energy of children dancing in the sunlight, their arms outstretched, the wind blowing through their hair, creates a flow of motion which has been caught at a peak of tension. The same sense of movement and rhythm fascinated her in American Indian tribal dancing and in modern dance.

Children Dancing by Lake, 1940, courtesy of Barbara Morgan

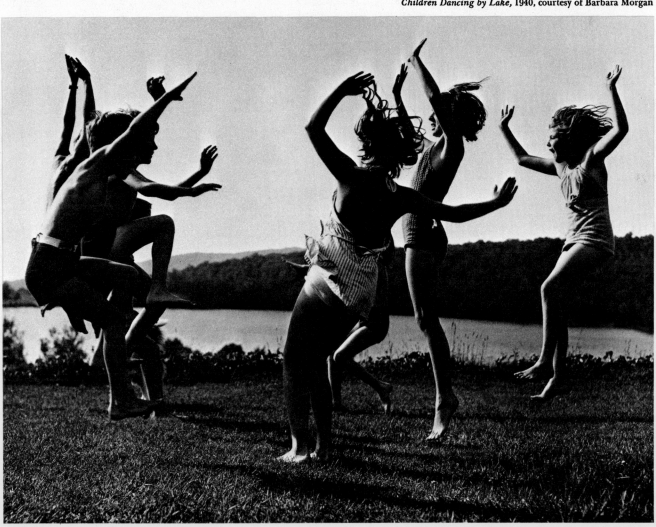

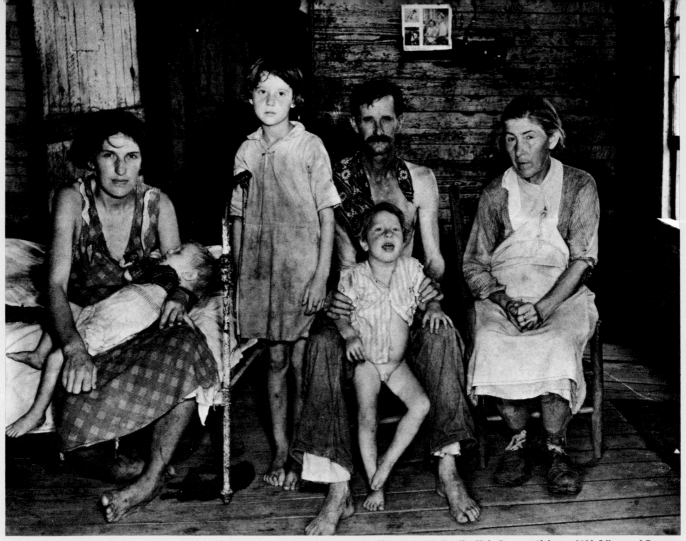

Sharecropper's Family, Hale County, Alabama, 1936, Library of Congress

With his camera Walker Evans seemed to look straight into people's faces, and deep
into their eyes. His subjects look at us with the same kind of directness. Evans made a series
of pictures of the American South during the bitter years of the Great Depression in the
1930's, when droughts and dust storms destroyed millions of acres of crops.

Evans's picture above was taken in the bare shack of a poor sharecropper, a farmer
who does not own land but pays rent for his fields with a share of his harvest. In spite
of their ragged clothing and bare feet, the children, their parents and their grandmother
look back at us with strength and courage.

During the Depression farmers were driven off their land when the crops failed. They drifted from place to place with their wives and children, looking for work. Dorothea Lange documented, or recorded, these jobless and homeless migrants. Lange photographed her subjects in natural arrangements, without posing them. This powerful picture shows a mother who is worried, yet proud and strong.

Migrant Mother, Nipomo, California, 1936, Library of Congress

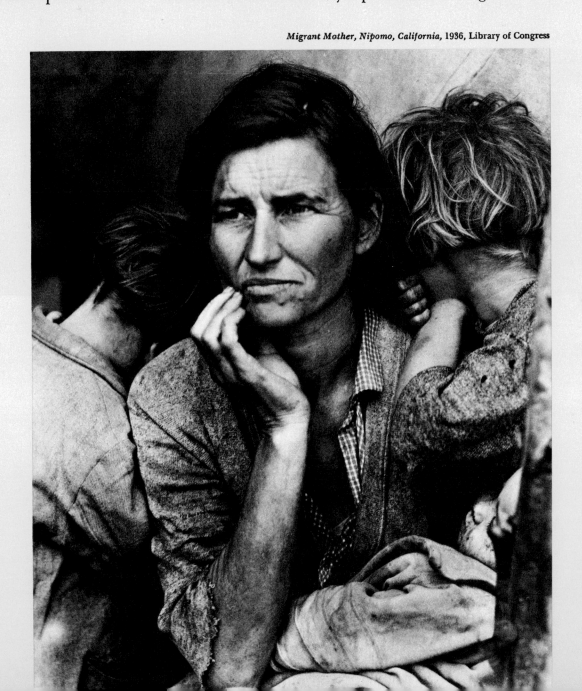

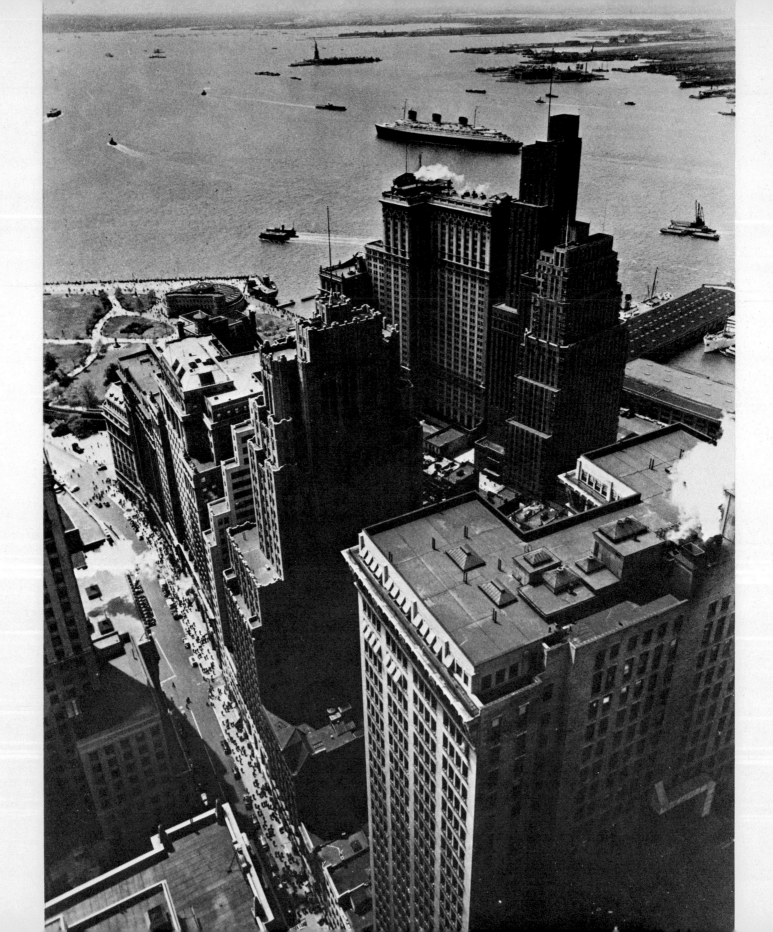

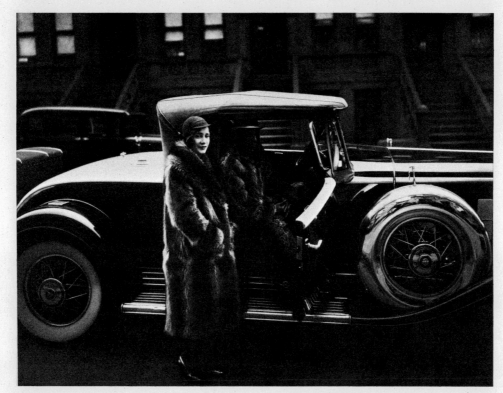

Harlem Couple, 1932, The High Museum of Art,
Atlanta, Georgia, Museum Purchase

Berenice Abbott focused her camera on the tall office buildings that line the streets of downtown New York. In the photograph at left, taken from a roof, the people and cars on the street below seem tiny next to the towering buildings. The view includes New York Harbor with an ocean liner and tugboats. In the background the Statue of Liberty can be seen. Abbott roamed the city making camera studies of architecture, which have become an important record of many buildings that have since been torn down.

For more than sixty years James Van DerZee, a Black American, worked as a portrait photographer in Harlem, a section of New York City. He took pictures of family groups, the fashionable life of the community, and famous Black sports champions, religious and political leaders, musicians and movie stars. Above, a fashionably dressed couple are posed with their elegant automobile.

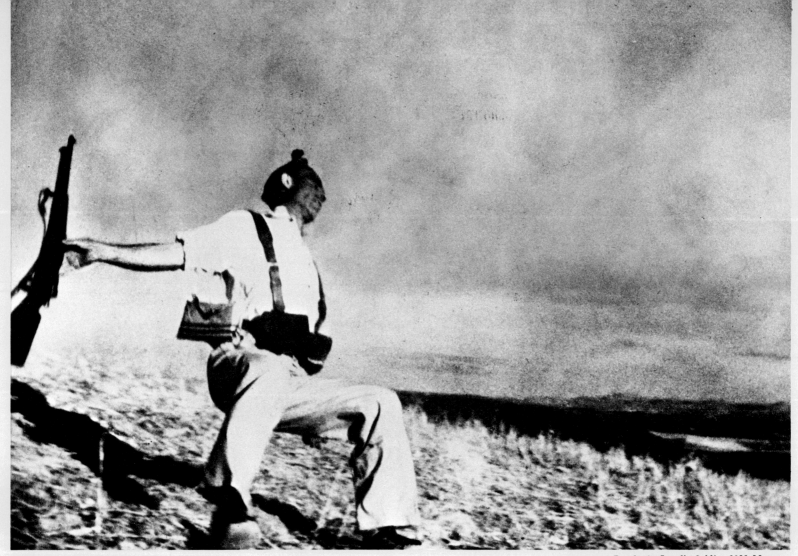

Death of a Loyalist Soldier, 1936, Magnum

In the mid-1930's when war broke out in Spain, Robert Capa went to the front lines

with his camera to report on the life and death of the fighting men. He took this startling

picture at the instant a Spanish soldier was struck by a bullet.

In the next eighteen years Capa went to war with his camera five times. While

advancing with the French troops in North Vietnam in 1954, he was killed when his jeep

ran over a land mine and exploded.

In World War II Margaret Bourke-White photographed for the United States Armed Forces. She almost lost her life on her way to North Africa when a troopship she was on was torpedoed and sunk. At the end of the war, Bourke-White was with American troops when they freed starving prisoners from Nazi concentration camps in Germany. The horrors of the prison camps are revealed in the haunting faces of the men in this picture.

Bourke-White worked for *Life*, which was America's leading picture magazine. Her photograph of a power dam was used on the cover of *Life*'s first issue, in 1936. She traveled all over the world on assignments for the magazine. In South Africa she went almost two miles under the earth to photograph miners at work.

Buchenwald Victims, 1945, Life Magazine © Time Inc.

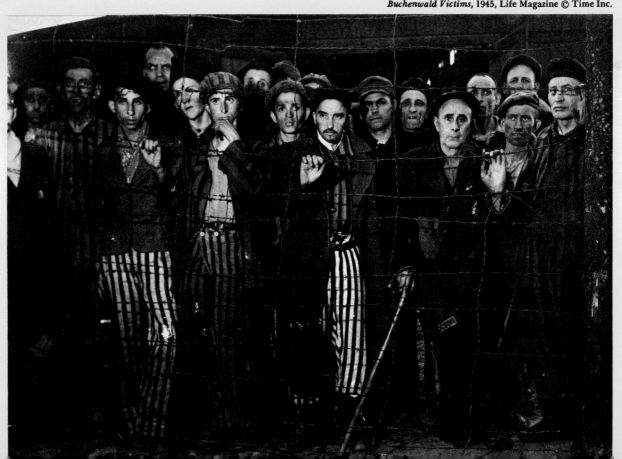

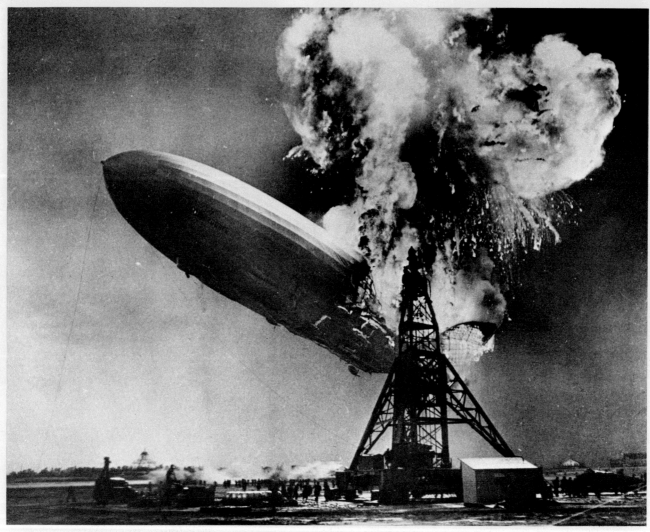

Explosion of the Hindenburg, 1937, United Press International

On the afternoon of May 6, 1937, twenty-two photographers were gathered at Lakehurst, New Jersey, waiting for the Hindenburg, a great silver dirigible, to descend. At dusk the enormous airship drifted in from over the Atlantic. As it floated down to its mooring mast and cameramen were preparing to take pictures, the Hindenburg suddenly burst into flames. In about one minute it fell to the ground, a heap of burning wreckage. Sam Shere caught on film the instant of the explosion.

The fast lenses and high-speed shutters on modern cameras make it possible for news photographers to capture fleeting moments. Robert H. Schutz was on hand when President John F. Kennedy was greeted by his little boy in 1963. The joy of the meeting is expressed by the child's leap into his father's arms.

Father and Son, Otis Air Force Base, 1963, Wide World Photos

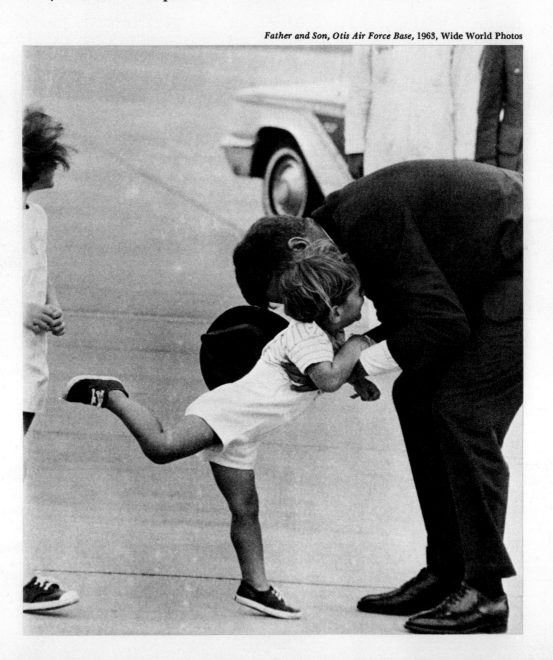

Philippe Halsman creates his own action with imagination and humor. He made hundreds of photographs of famous people jumping, which he published in a book. Halsman had the idea of making a photograph of the painter Salvador Dali in which everything, including the artist himself, would be floating in the air. To prepare for the "shooting," he suspended two pictures, an easel and a little bench on thin wires, while a hidden person held up a chair. At a signal Dali leaped up, holding a paint brush, three people threw cats into the air, and another tossed a bucket of water across the room. It took five hours and twenty-six attempts before the photographer was satisfied with the results.

Dali's Cats, 1948, Copyright © by Philippe Halsman

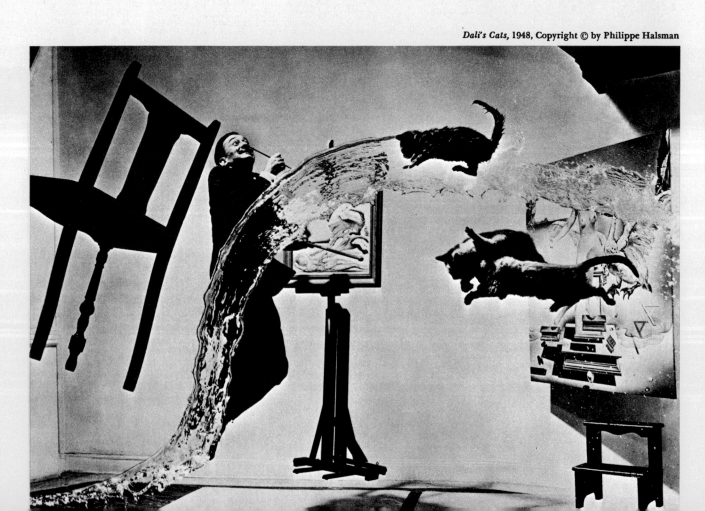

46

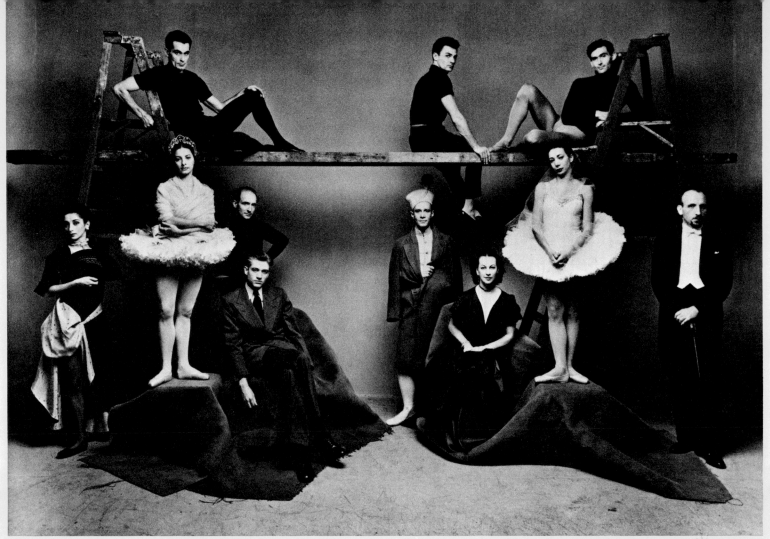

Irving Penn poses his subjects in the simplest surroundings so there will be no

distracting background. To photograph a New York ballet company, he organized the

ballerinas, the male dancers, the conductor of the orchestra and the dance director

into a studied arrangement that gave each of them equal importance. The ballerinas in

their white costumes balance each other and stand out against the figures in black

and gray. Above them are male dancers in relaxed poses. A touch of the real combined

with the make-believe is added by the dancer dressed in a jeweled turban and an overcoat.

47

The figure of a boy twisting in midair is a study in pure form in this photograph by Aaron Siskind. Is the figure rising or falling, or is it floating in space? Since there is no background, it is impossible to tell. Siskind reveals abstract shape, without interest in subject matter.

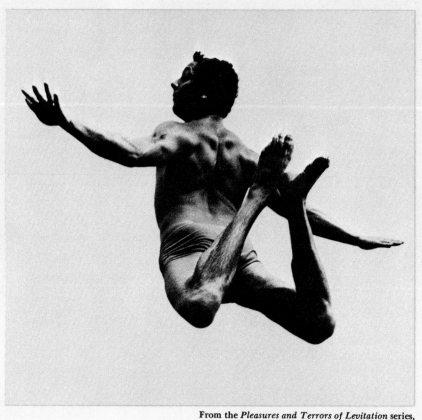

From the *Pleasures and Terrors of Levitation* series, 1961, courtesy of LIGHT Gallery, New York

Cameras today seem very different from the first large, clumsy boxes which came into use around a hundred and fifty years ago. Extraordinary lenses, which can magnify a molecule or peer into the stars, have replaced the pinhole openings of the original cameras. Shutters open and close in a thousandth of a second compared to the long exposures required in the early days of photography.

Although everything is faster and more efficient, the basic principles of photography remain the same. And today, as in the past, the camera alone cannot take a significant picture. It requires an artist with a special vision to make a photograph a work of art.

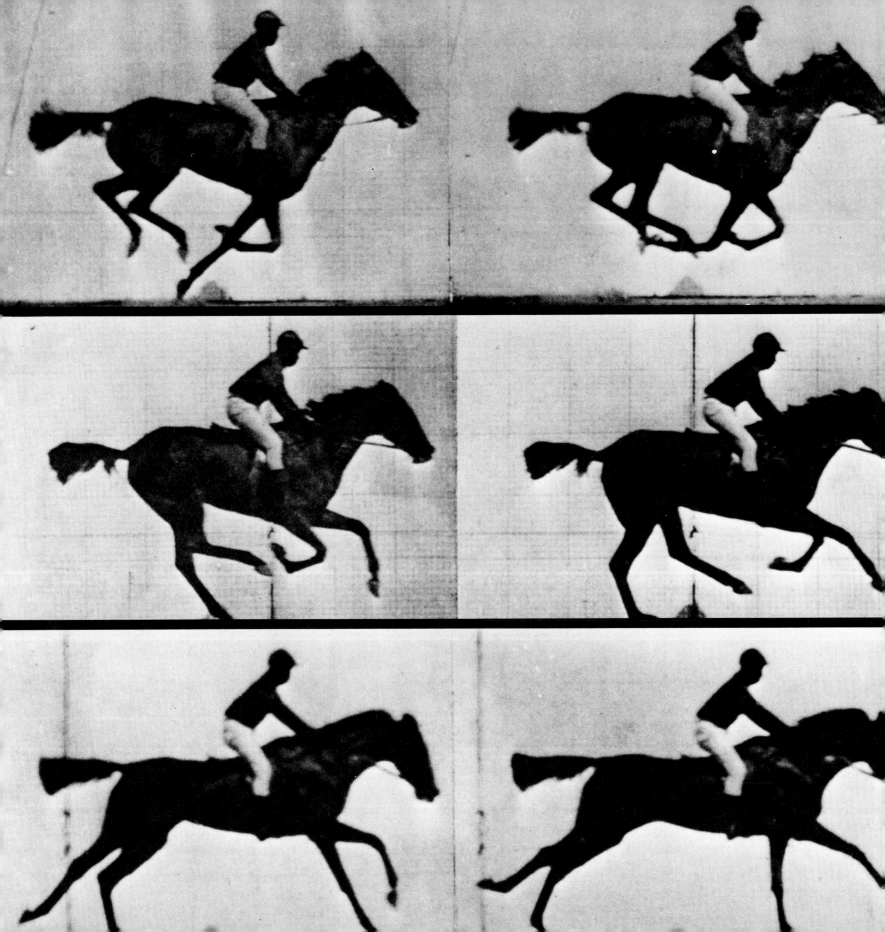